Witch, PLEASE!

MAGICAL MUSINGS ON LIFE, LOVE, AND OWNING YOUR POWER

by

Sonia Lazo

CHRONICLE BOOKS

SAN FRANCISCO

Library of Congress Cataloging-in-Publication Data available.

ISBN: 978-1-4521-7668-0

Manufactured in China.

MIX
Paper from
responsible sources
FSC™ C136333
www.fsc.org

10 9 8 7 6 5 4 3 2 1

Chronicle books and gifts are available at special quantity discounts to
corporations, professional associations, literacy programs, and other
organizations. For details and discount information, please contact our
premiums department at corporatesales@chroniclebooks.com or at
1-800-759-0190.

Chronicle Books LLC
680 Second Street
San Francisco, California 94107
www.chroniclebooks.com

to my PARENTs, my magical FRiENDs, AND ALL tHE witchES ARoUND the world WHO iNSpiRE ME to coNtiNUE cREatiNG. ♥

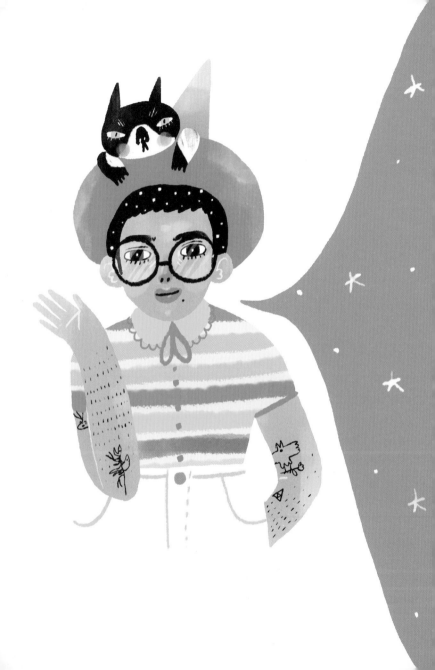

Hi! I'm SONIA AND I'm AN illustRAtOR FRom tiny, tiny, oh-so-tiny EL SALVADOR. I'm ALSO A tropicAL witch who Needs to BE coNstANtly cREAtiNG OR elsE GEts bummed. But ENOuGH About mE; I'm SO GLAD you'RE READiNG tHis! tHAt mEANS you'RE ALSO A witch, OR you must bE iNtEREStED iN becomiNG ONE. You'RE dEfiNitEly wElcomE iN my covEN. I HAVE ALwAys bEEN FAsciNAtEd by ouR histoRy ANd ALl thE mAGic wE cARRy iNSidE.

I'll bE showiNG you whERE wE comE FRom, whAt it mEANs to bE A witch, ANd whAt AmAziNG stuff wE cAN dO. One of ouR mAiN objEctivES AS witchES is to bE AblE to chANGE ouRSELvEs ANd thE woRLD ARouNd us FoR thE BETTER. WE hAVE So much POWER withiN us, So i HopE this book hElps you GRow ANd lEARN How to tAp iNto thAt POWER. So Go AHEAd ANd ENjoy it!

LOVE,

SONiA

OK so, truth is, witches haven't always had a good REPUTATION.

IN FACT,

they were Labeled as :

- EVIL
- DEVIL WORSHIPPERS
- SCARY
- OLD
- UGLY and with BIG NOSES

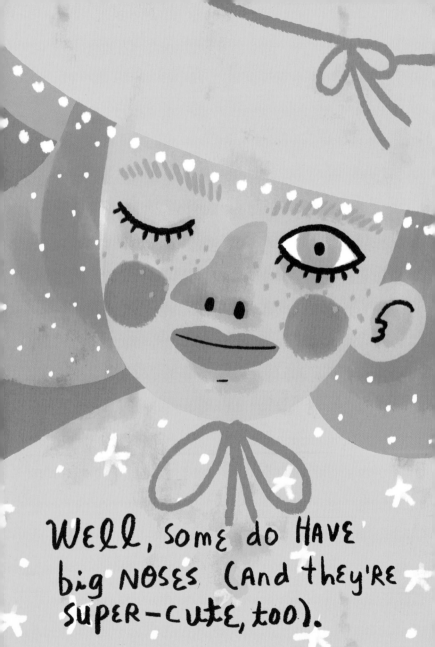

WELL, SOME do HAVE
big NOSES (AND THEY'RE
SUPER-CUTE, too).

But REALLY, witches ARE POWERFUL and can do AMAZING thiNGs—

LiKE MAKE HEALiNG potions using thEiR Knowledge of HERBS AND NATURAL REMEdiES;

CREAtE AMULEts to PROtEct, hELP, OR HARM thEiR nEiGhbORS; PERFORM diviNAtion rituals;

- and gEnERALLy - HANdLE thEiR BUSiNESS.

THE SUN

THE MOON

In early modern Europe, that made people SCARED, because they weren't used to women asserting power.

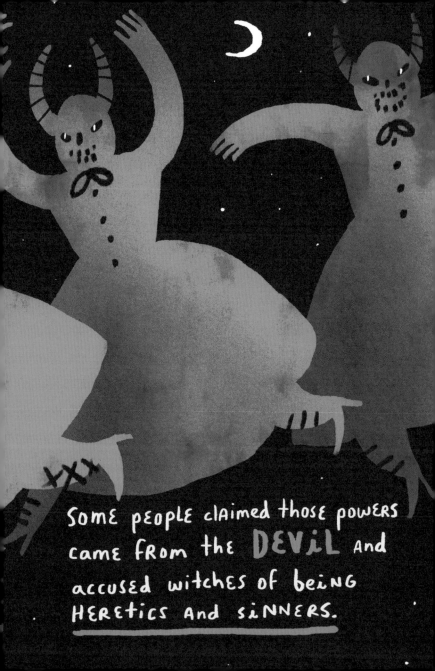

SOME PEOPLE CLAIMED THOSE POWERS CAME FROM THE **DEVIL** AND ACCUSED WITCHES OF BEING HERETICS AND SINNERS.

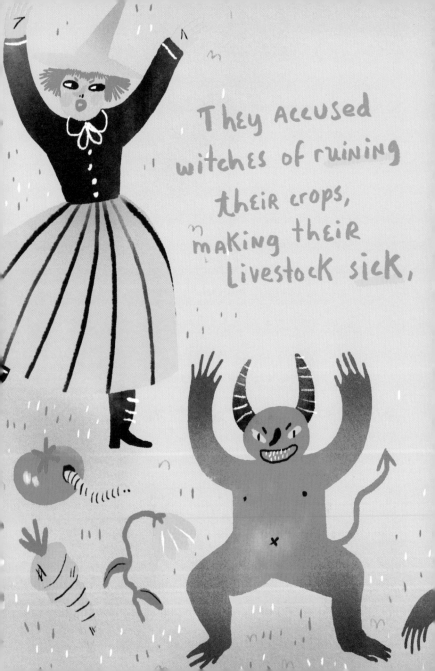

They Accused witches of ruining their crops, making their Livestock sick,

and
having **wild**
parties where
they danced with
DEMONS and
harmed people.

All that hysteria led to **Witch-hunting**, a terrible practice that resulted in **thousands of executions** between the 16th and 18th centuries, mostly in Western Europe.

So we have a really **dark past**...

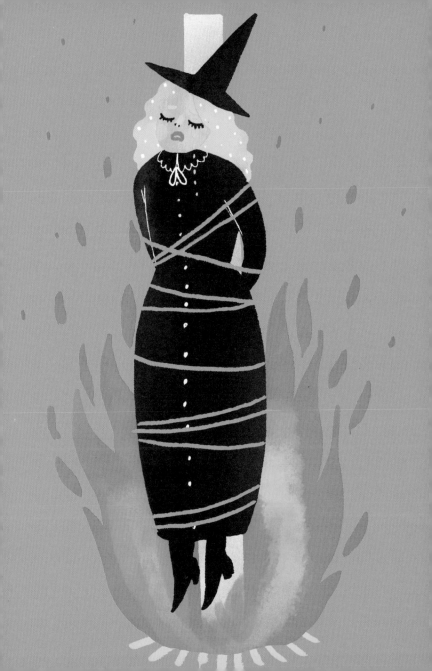

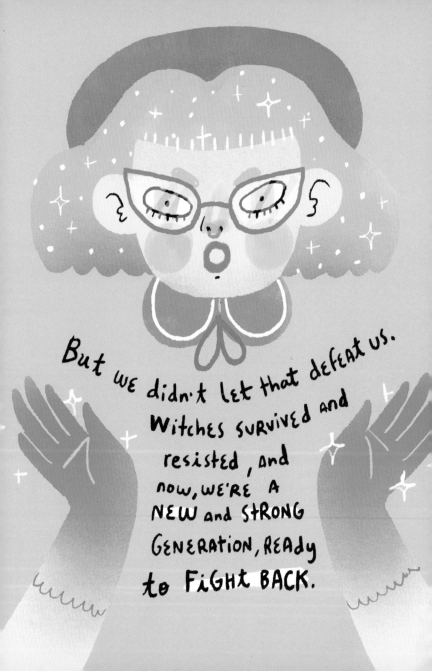

But we didn't let that defeat us. Witches survived and resisted, and now, we're a NEW and STRONG GENERATION, READY to FIGHT BACK.

THERE HAVE BEEN SO
many incredible witches.
Let me introduce you
to just a few of my
favorite magical
practitioners who are
important parts of our
Witchstory.

.HECATE.

HECATE WAS the ancient GREEK goddess of the wilderness and of childbirth. She was also considered a goddess of SORCERY and had the POWERS to KEEP EVIL out—and to let it in if she was offended. SHE WAS Also said to be an AMAZING HERBALIST.

Alice Kyteler was the first condemned woman for witchcraft in Ireland. She had been married four times and all her husbands ended up dead, leaving her to inherit everything. She was accused by her children and found guilty of witchcraft, but she managed to escape her grisly fate and was never heard from again.

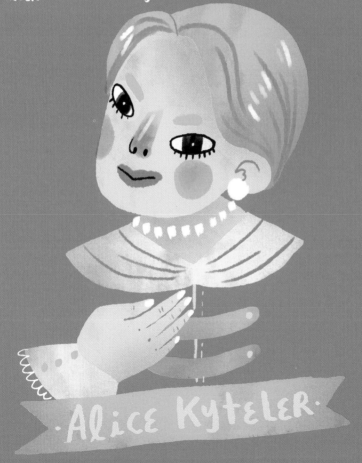

·Alice Kyteler·

Marie LAVEAU, also Known As the Voodoo Queen. Born in New Orleans in the mid 1700s, she was extremely well Respected. People from different places and social classes would come to her seeking advice—and maybe a potion or a spell—Regarding health or love.

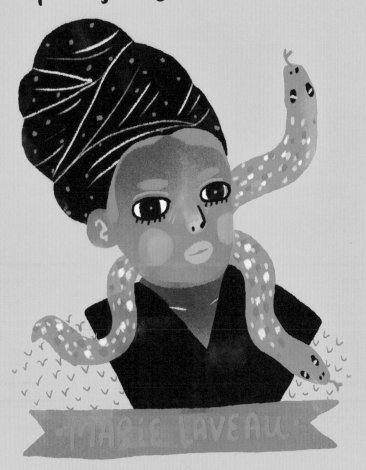

MARIE LAVEAU

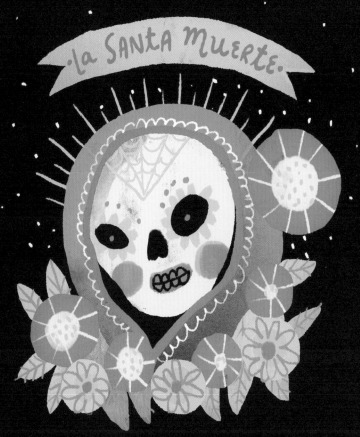

·La SANTA MUERTE·

La SANTA MUERTE is an important character of Mexican culture. She is deeply connected to witchcraft and holds several magical powers. She heals and protects the recently deceased and brings them safely into the afterlife.

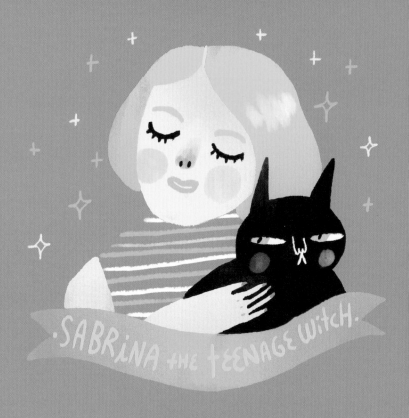

. SABRINA the TEENAGE WitcH.

Sabrina the Teenage witch is, yes, a
fictional witch, but still one that
introduced witchcraft and magic to
young kids (including myself) in such
a fun and pure way. Sabrina was the
stylish, cool, and sweet witch we all
wanted to be friends with.

HERMIONE GRANGER is another fictional and very popular modern witch. And a pretty good example of the TRUE nature of witches: smart, kind, good-hearted, a bit stubborn, but always trying to do the right thing.

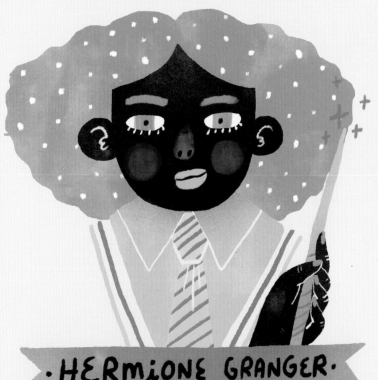

· HERMIONE GRANGER ·

So, what does it mean to be a WITCH in this day and age? Well, here's what I think:

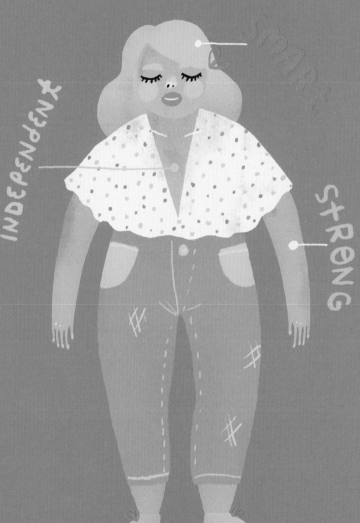

It also means you're
aware of your POWER
and you know your VALUE—

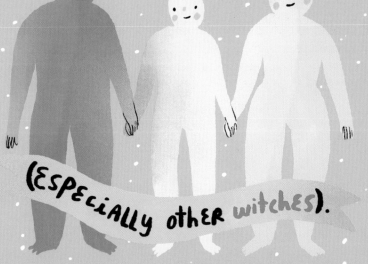

and the VALUE of OTHERS

(ESPECIALLY other witches).

But of COURSE
we still have
MAGIC—you
know: the
SPELLS,
PotiONS, and
CHARMS.

What i LiKe
the BESt is the
spiRitual
side of MAgic.
It helps us
focus on positive
ENERGY
and BELiEViNg
iN OURSELVES.

And using that ENERGY and power to benefit others too.

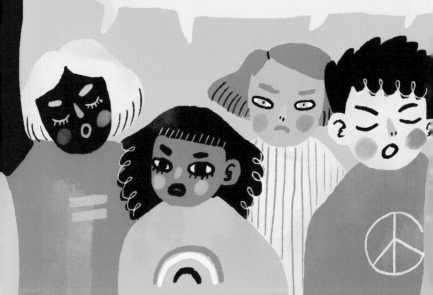

Equality and Respect

For example, many witches engage in a lot of activism.

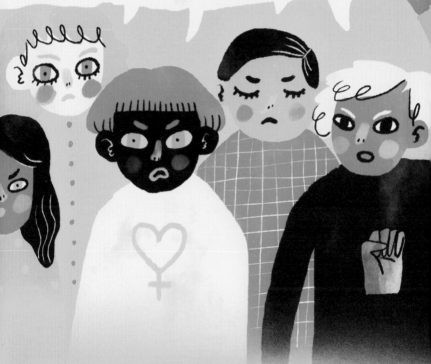

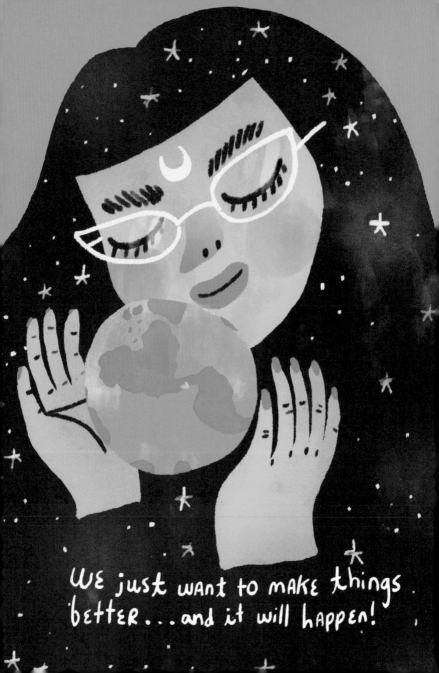

And speaking of equality, this is important:

Witches ARE DIVERSE! they do NOT have a REQUIRED look.

THEY CAN
bE **ALL SiZES,**

SHAPES, AND COLORS.

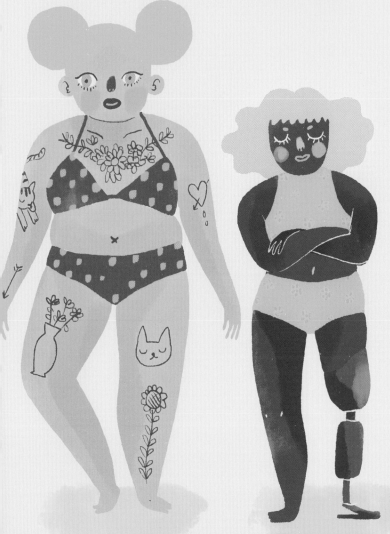

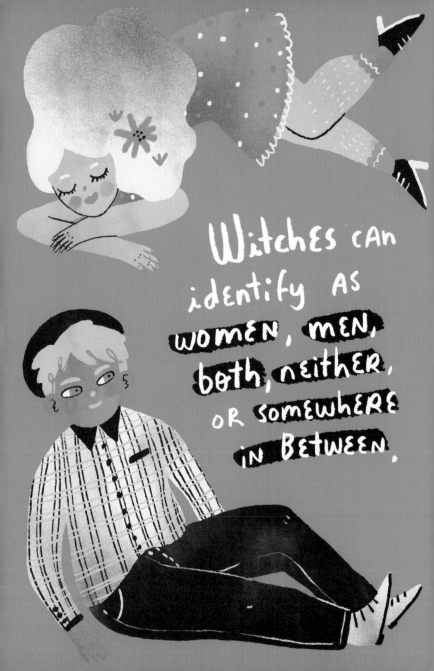

Witches can identify as women, men, both, neither, or somewhere in between.

It is

NO ONE'S
BUSINESS
but THEIR
OWN.

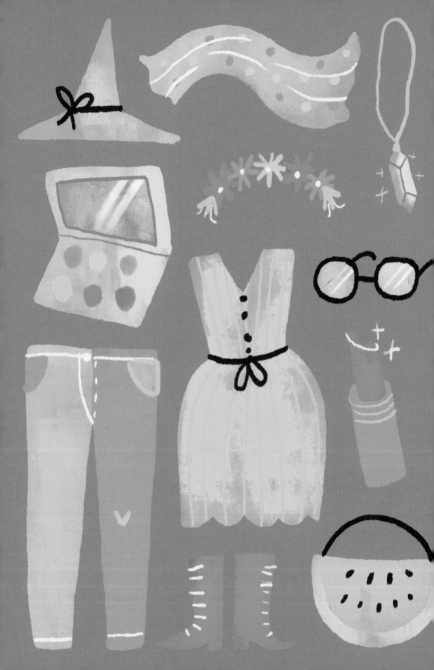

is Extremely
important for
witches, and
some use clothes,
makeup, and
accessories
to achieve it.

Witches can dress however they want, and they can be **VERY** stylish.

Some go for a black-and-white look.

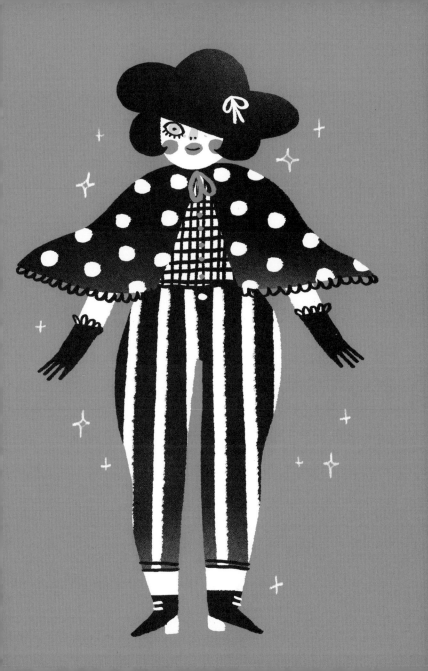

SOME (LIKE ME!) LOVE to LOOK LIKE A RAINBOW.

SOME GO FOR A VERY CLASSICAL LOOK.

OR FOR AN
EXTREMELY
FUTURISTIC
LOOK.

And it's the same with makeup.
Some prefer to let their natural beauty shine,

AND SOME like to get EXTREMELY CREATIVE and Experimental with how they paint their FACES.

Either way, it's about what makes them FEEL good.

Oh, And Let's NOT FORGET about ACCESSORIES! Cool hats and jEWELRY AND glASSES AND DIY stuff.

It's all about having FUN.

But being a witch is not just about getting the right Look.

Witches are constantly learning and practicing new things.

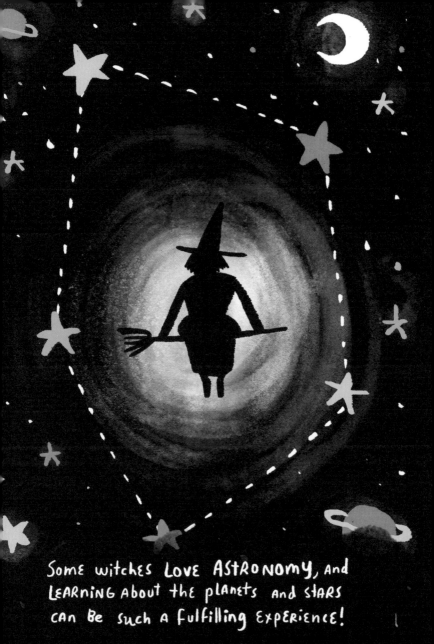

Some witches LOVE ASTRONOMY, and LEARNING about the planets and stars can be such a fulfilling experience!

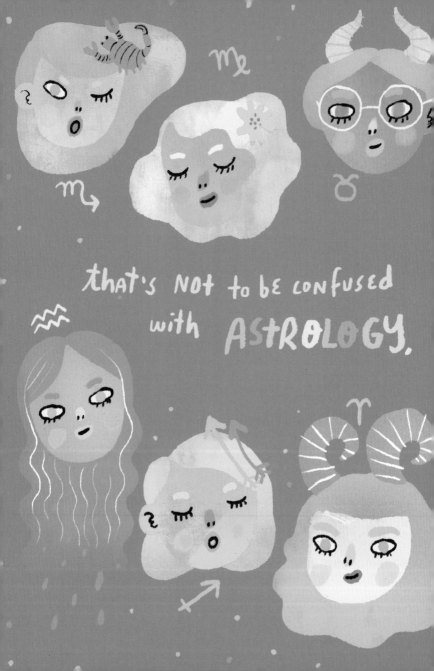

that's NOT to be confused with **ASTROLOGY.**

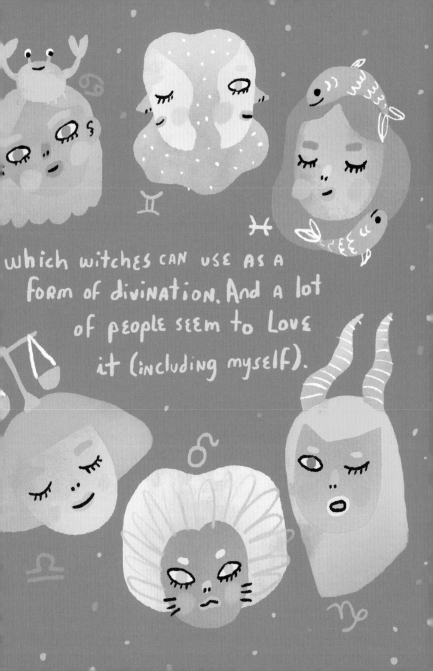

which witches CAN USE AS A
FORM of DiviNATION. And a lot
of people seem to love
it (including myself).

HERBALISM is also extremely interesting. Some witches can spend months growing magical plants and

learning all of their properties. Gotta be careful with the MANDRAKES, though!

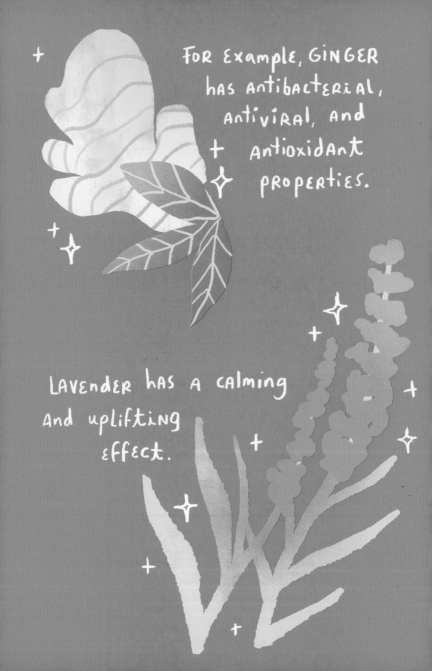

FOR Example, GINGER has Antibacterial, Antiviral, and Antioxidant PROPERTIES.

LAVENDER HAS A calming and uplifting effect.

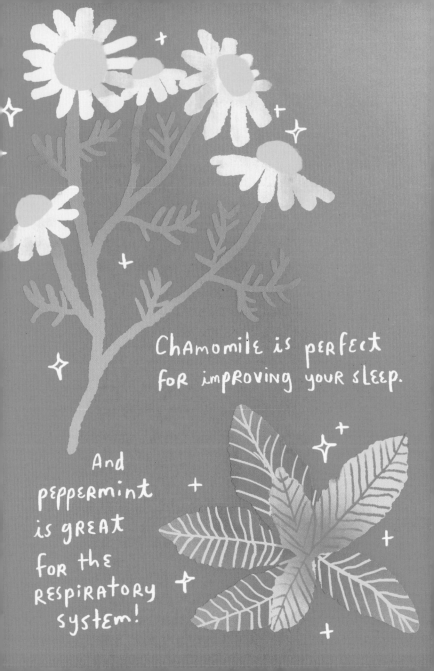

Chamomile is perfect for improving your sleep.

And peppermint is great for the respiratory system!

Some herbs can be put to use in making potions. It can be a bit tricky, and some ingredients are very hard to find, but a witch can do a lot of good once she learns the basics.

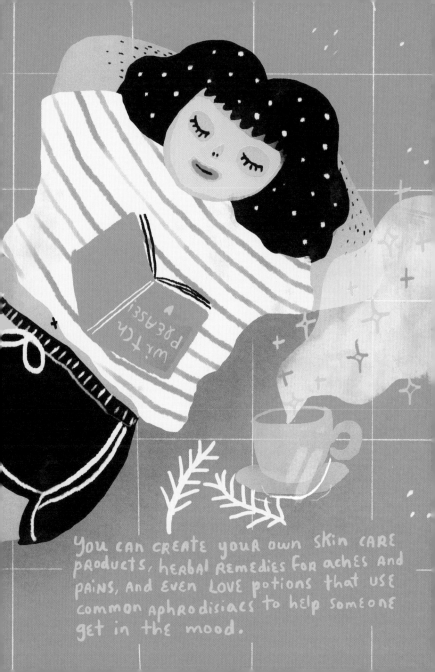

You can create your own skin care products, herbal remedies for aches and pains, and even love potions that use common aphrodisiacs to help someone get in the mood.

Knowing how to fly is also essential. Forget about the brooms! We have planes and helicopters and even jetpacks now! (Let's be honest, it's way more functional this way.)

Of course, witches are devoted to taking care of living creatures and studying the magical ones.

Dragons, hippogryphs, unicorns, and phoenixes are very uncommon, but i haven't given up hope I might find one of them someday.

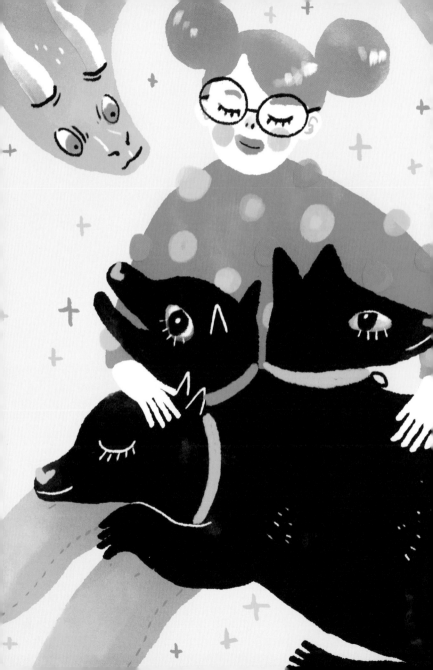

Witches also enjoy EVERYDAY activities like hanging out with FRIENDS.

SOME ARE EXTREMELY Good at cooking And MAKE delicious MAGICAL RECIPES.

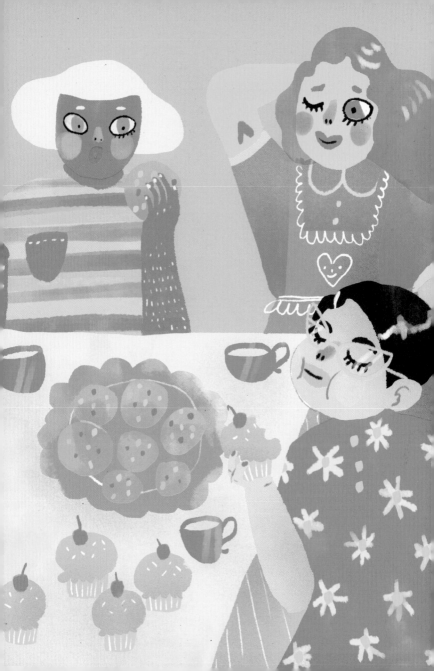

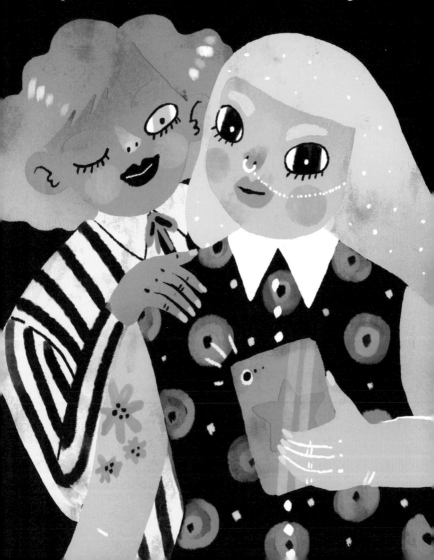

So can going hiking and communing with NATURE!

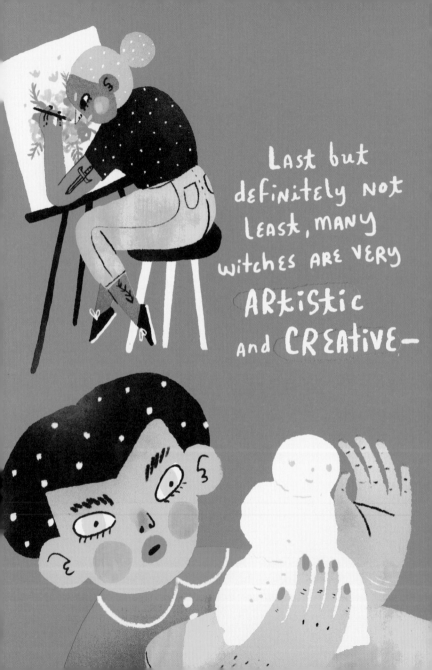

Last but definitely not least, many witches are very ARTISTIC and CREATIVE—

they can
be into
PAINTING,
SCULPTING,
PHOTOGRAPHY,
writing,
music,
and
so on.

OR they might Just ENJOY:
APPRECIATING
ART AND GOING
to MUSEUMS
AND ART
SHOWS.

Also, most witches have familiars, which are supernatural entities that take the form of animal creatures to assist them in their practice (and keep them company).

Familiars come in many forms. The most popular ones are black cats, rats, frogs, bats, and hares.

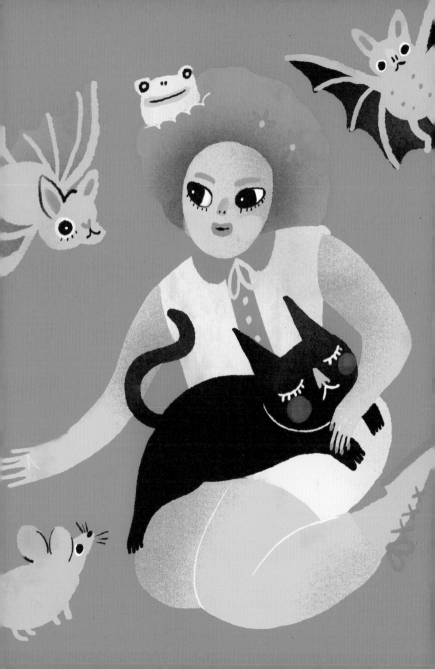

It's not just about familiars, though—

witchES ALSO NEED
to bE AROund
OthER witchES.

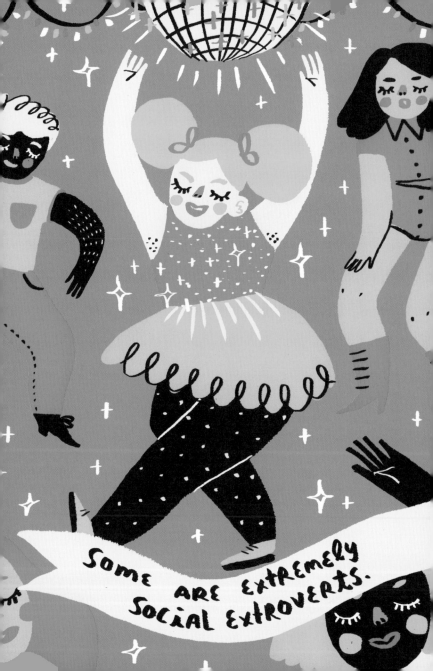

SOME ARE EXTREMELY SOCIAL EXTROVERTS.

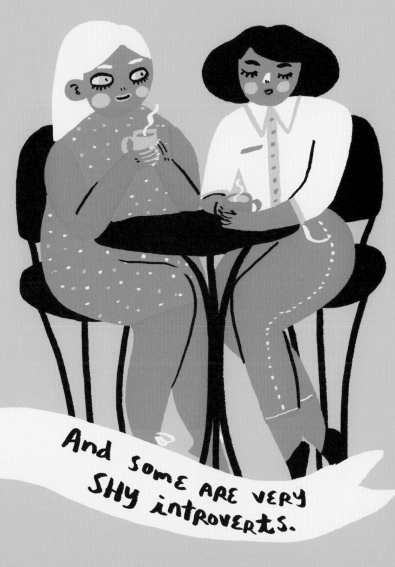

And some are very shy introverts.

BUT EVERYONE
should HAVE THEIR
OWN <u>COVEN</u>,

whether it's A SMALL

OR A BiG ONE.

Witches keep each other strong
and support one another.

If someone has a problem, the whole crew is there to help, ALWAYS.

And, like just about everyone, witches also NEED And DESERVE LOVE.

Sometimes they find it outside of their coven, And sometimes they fall for a fellow witch.

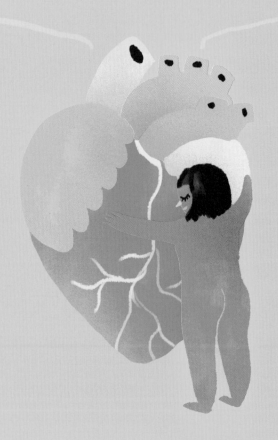

When witches fall in LOVE, they fall
for the person's personality and heart.

they enjoy being in RELATiONSHiPS
that bring out the best in them,

WHERE THEY CAN BE THEMSELVES,
GROW, AND LEARN.

THERE ARE times that
things don't work out so great,

because NOT EVERYONE has good intentions.

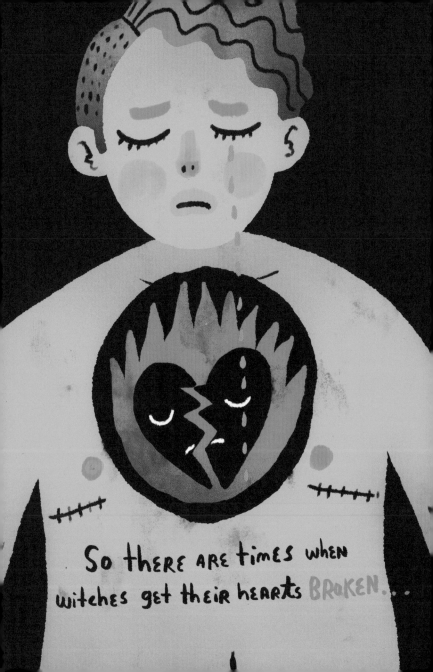

So there are times when witches get their hearts BROKEN...

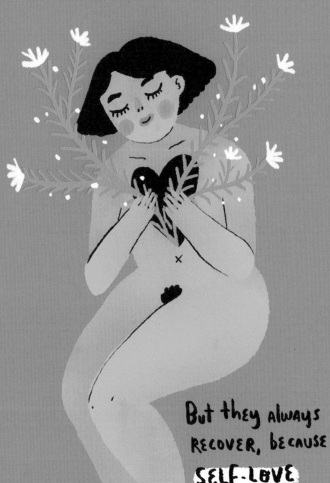

But they always
RECOVER, BECAUSE
SELF-LOVE
comes FIRST.

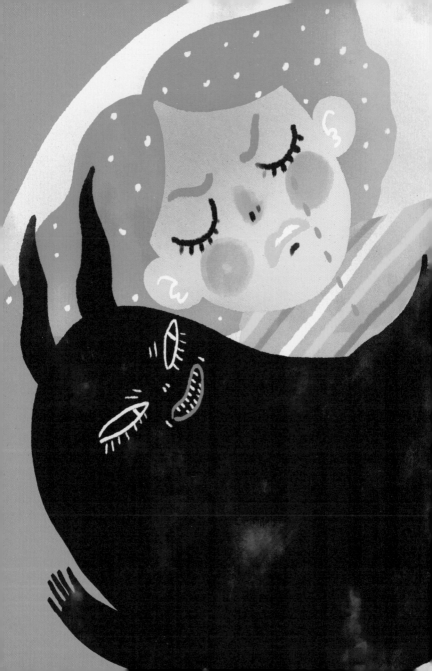

So, yeah, things AREN'T always PERFECT FOR witches. THERE ARE times WHERE PROBLEMS ARISE AND WE CAN FEEL REALLY

SAD,

TIRED,

STRESSED,

LONELY,

OR ANGRY.

It's important to always take some time for yourself.

Self-care can actually help you address a lot of negative feelings.

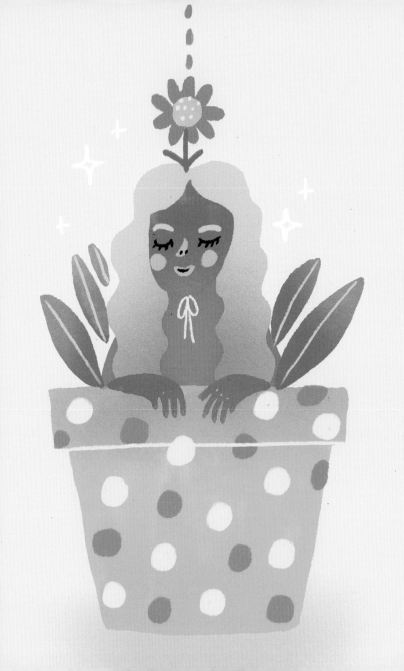

Things like taking a warm bath, meditating, spending time outdoors, or just getting a good night's sleep can really do wonders for your well-being.

Expressing your feelings is also extremely important, whether it's with other witches or with a trusted therapist or counselor.

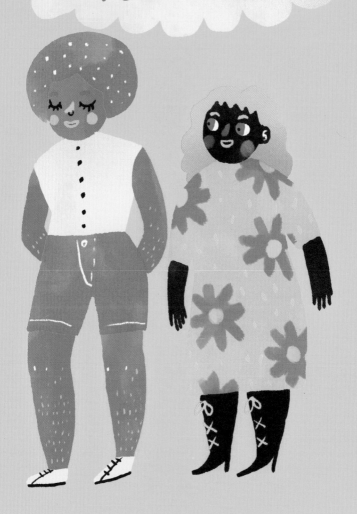

So, you still want to know more about

Witch
Culture?

HERE ARE SOME
things that might
interest you:

BOOKS

-The Witches
by Roald Dahl

(Well, we're portrayed kinda
badly here but think of it
as a satire.)

-Las Cartas de las Brujas
by Isa Donelli

the perfect book to get you
into divination and card reading.
It also includes a whole deck!

-All the Harry Potter
Books by J.K. Rowling

Of course you know these
already but definitely a
must! (This also applies
to the movies.)

MOViES

-the Witch

A classic folktale
involving my favorite
animal, goats! ♥

-the CRAFt

(teenage witches gone
DARK? YES, pLEASE!)

-the LOVE Witch

A lovely feminist satire.

TV SERIES

SARRINA the TEENAGE WITCH

Yes, again.

Buffy the Vampire Slayer

OK, so it's more about vampires,
but there ARE some incredible,
iconic witches there, like
queer legend Willow!

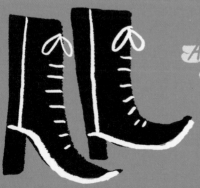

AMERICAN HORROR STORY: COVEN

PRETTY SELF-explanatory.

Oh, we're reaching the end now,

AND I HOPE you enjoyed READing this. If you WEREN'T a witch already, then now you know how exciting it is to be one. JOIN US!

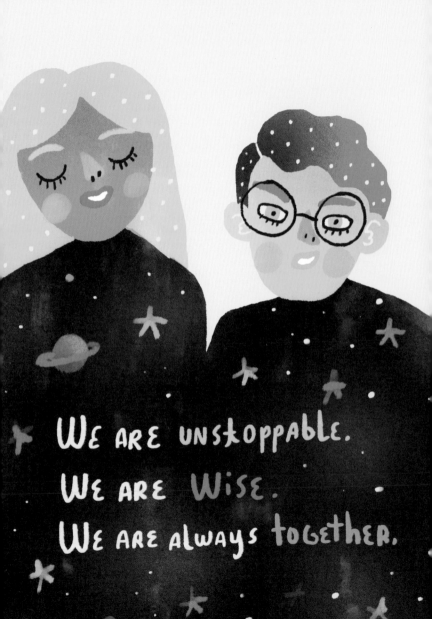

WE ARE UNSTOPPABLE.
WE ARE WISE.
WE ARE always toGETHER.

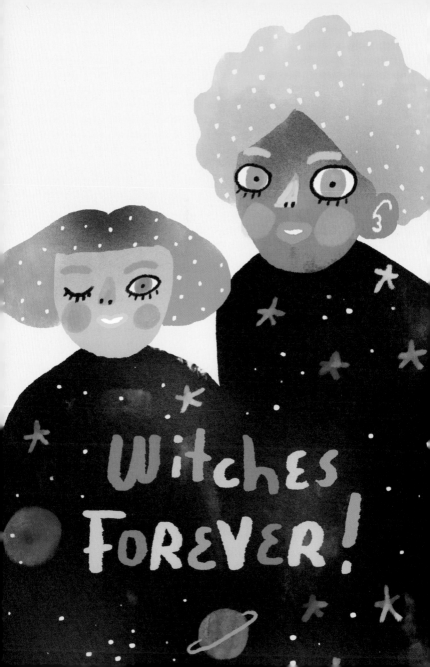

ACKNOWLEDGMENTS

Well, I would definitely not be here if it weren't because of my amazing, loving, and understanding parents, who have always supported me, even when they weren't sure about me pursuing an unconventional creative career. Can't blame them, I honestly had no idea what I was doing back then, but hey guys! I'm doing it right!

My two older brothers as well, they are an example of determination and courage, and I might not say it, ever, but I truly admire them both.

My lovely diamond friends, queer and proud, we've learned so much together here in this little country, the most valuable lesson is knowing how we can just be ourselves and that can make a difference here, even if it's by small steps.

I'm also extremely thankful to so many people that I don't really know in person, who follow me and support my work through social media, they have helped me grow so much! So yay for strangers in the internet! I have so much love and gratefulness for all of you. ♥ ♥ ♥

Finally Natalie, for reaching out and believing I could do this. This is the first book I've written and illustrated, and your guidance and help have been too valuable. Thank you!

♥ Sonia